American Indian Pottery

Sharon Wirt

hancock

house

Photos by Carol S. Mitchell

ISBN 0-88839-134-X
Copyright © 1984 Sharon Wirt

Cataloging in Publication Data

Wirt, Sharon
American Indian pottery
1. Indians of North America — Pottery.
I. Title.
E98.P8W57 738.3'08997 C82-091242-5

Editors Margaret Campbell & Mitchell Barnes
Typeset by Lisa Smedman in Times Roman on an AM
 Varityper Comp/Edit
Production & Layout Lisa Smedman
Photos by Carol S. Mitchell, unless otherwise indicated
Printed in Canada by Friesen Printers

Published simultaneously by

Hancock House Publishers
1431 Harrison Avenue, Blaine, WA 98230
Hancock House Publishers Ltd.
19313 Zero Avenue, Surrey, B.C., Canada V3S 5J9

Table of Contents

Acknowledgments

As this book is wholly based on an exhibit prepared by the author at the American Indian Archaeological Institute (AIAI)— a research, education, and museum center in Washington, Connecticut—much of the credit for the book goes to those staff members there who generously helped research Native American pottery as well as edit the text for the exhibit. Specifically, my gratitude goes to Joan Cannon, AIAI Museum Shop Manager, who gathered information and artfully edited much of the text; Dr. Russell Handsman, AIAI Director of Field Research, whose editing and vast knowledge of new archaeology and anthropology guided the preparation of the exhibit; Susan Payne, Director of Development, whose fine grasp of the technological aspects of pottery making was a substantial contribution; and to Jean Pruchnik Harrison, former AIAI cataloguer and artist, who expertly researched design aspects of pottery.

My thanks to the Institute in general for affording me the time to undertake this project, for the loan of slides, and for the use of its pottery collection for photography.

I am indebted also to photographer Carol S. Mitchell, whose patience and good humor were greatly appreciated during a few difficult, unorthodox photographic sessions.

Of course most of the credit goes to the real "authors" of this book, those Native American potters, past and present, whose stunning creations intrigue, inform, grace, and inspire.

About the Author

Sharon Wirt earned her master's degree in anthropology at the State University of New York at Buffalo and has pursued a varied career in editing, teaching, and exhibit design in museums and universities in Kansas and the Northeast. Residing in Woodbury, Connecticut, she is involved in the women's movement, literacy programs, and art in her free time.

Introduction

Pottery is neither simple nor purely utilitarian. Its development represents a conceptual leap in the history of human invention, involving the transformation of the most elemental materials of human experience—earth, water, and fire. It is both an art and a step in the process of survival.

Native American peoples produced a rich diversity of vessels, and expressed their distinctive philosophies and lifestyles through its use, design, and handling. Today, archaeologists study these artifacts for clues to the behavior of the early Americans.

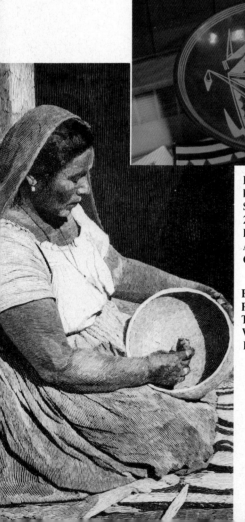

Polychrome plate by internationally known Maria Martinez and Popovi Da, San Ildefonso Pueblo, New Mexico, 20th century.
Photo courtesy of the American Indian Archaeological Institute, Washington, CT.

Engraving of Southwestern potter. Plate XL in *Bureau of Ethnology*, Third Annual Report (1881-1882), Washington, D.C.: Government Printing Office.

Pottery: An Archaeological Tool

One of the uses of pottery, unforeseen by its originators, is as a tool to examine the past. Archaeologists have studied individual specimens and discovered the sophisticated technological know-how of Native American potters, who invented resist decoration (in the Southeast) and stamping, who learned how to control air flow in the firing process to create color patterns, and who discovered how to stabilize clay pots, enabling them to build pots as large as 6 ft. (1.8 metres).

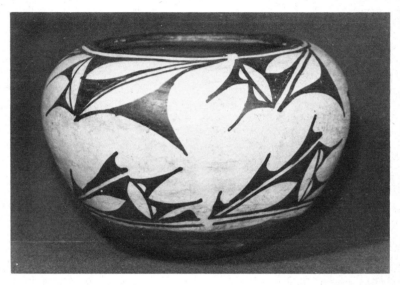

Southwestern Pueblo vessel (San Ildefonso or Santo Domingo, New Mexico), probably early 20th century.
Gunn Memorial Library and Historical Museum Inc. collection.

Sketches of potsherds by Jean Pruchnik.

By analyzing the origins of the clay and the temper, the mode of manufacture, the decoration, and how specimens were associated with other artifacts in an archaeological site, researchers have been able to trace such things as trade networks, movements of groups, and social stratification.

Before the 1960s, archaeologists described a society by its technology, settlement, food systems, social structure, and other characteristics. Ceramics were considered evidence of a people's shared activities and cultural traits. Analyzing such features as clay origin and color, texture, vessel shape, thickness, and design, archaeologists grouped pottery remains by type and used these types to identify different social groups.

Traditional archaeologists believed that by piecing together these bits of evidence they had unearthed, they could discover whether changes in lifestyle resulted from new ideas within the group or from outside influences. To show how cultures change through time, they also developed chronological charts—arrangements of ceramic types according to time period, like the one shown here:

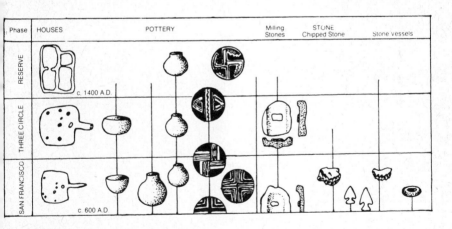

Portion of chart showing development of Mogollon culture in the Southwest. (After Martin et al., in Gordon R. Willey, *An Introduction to American Archaeology*, Vol. 1, 1966, Englewood Cliffs, NJ: Prentice-Hall, Inc., p. 198.)

In the 1960s, researchers known as the "new archaeologists" began looking at the record of the past, including ceramics, with different questions and insights. They became aware that traditional archaeologists had excavated their sites according to

unconscious, implicit assumptions. It had long been assumed, for instance, that different ceramic styles reflected either different cultures or a change within a culture, depending on the archaeological context of the pottery. The new archaeologists suggested instead that some of this ceramic patterning in a society could reflect its varied settlement and behavior patterns.

The new archaeologists were particularly interested in the behavior of a society and the processes involved in how and why a people "select" a certain kind of food, technology, religion, settlement, social and aesthetic system. With the aid of computers and specialists from other disciplines, they succeeded in extracting new information from the record of the past. However, they were also determined to articulate their assumptions and test them scientifically. This produced a fresh approach to archaeology. The new archaeologists formulated a hypothesis and deduced from it the kinds of evidence that they would expect to find if their assumptions were correct. Then they tested the hypothesis against the actual archaeological record.

The methods used by one of the new archaeologists, William Longacre, illustrate this new system. In 1961-1962 he discovered that there were several distinct pottery styles within an approxi-

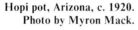
**Hopi pot, Arizona, c. 1920.
Photo by Myron Mack.**

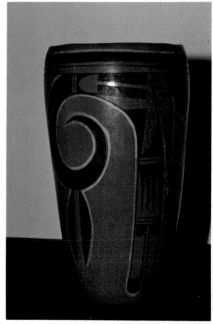

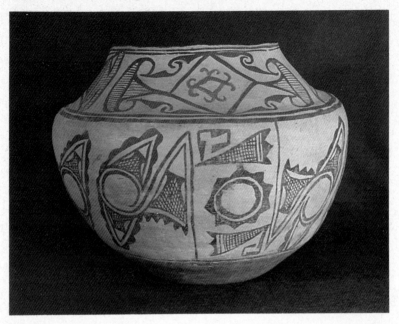

mately three-thousand-year-old pueblo settlement in Arizona. Longacre maintained that some of these styles reflected distinct activities or behaviors of one residence group, and that the remaining styles were associated with another family group living in another part of the pueblo. He arrived at this conclusion by first preparing a statistical computer analysis of the site that revealed several clusters of pottery types. He then assumed that these types had been associated with different purposes and with different family groups within the pueblo, and began testing this hypothesis against the data. A statistical analysis revealed that certain types of pottery were associated with certain rooms, shown by existing archaeological records to have been used for particular activities. Further analysis revealed two main clusters of design styles, which probably reflected the activities and habitation of two families or clans. Thus Longacre's hypothesis was proved valid to a high degree.

New archaeologists believe that ceramics are just one of many factors involved in understanding the behavior of a people. They view society as a dynamic system, and use ceramics as one of many tools to try to understand the people of the past.

Secular and Sacred Ceramics

Like people from many other technologically complex cultures, North Americans tend to compartmentalize their lives, dividing the sacred from the everyday. However, in every culture there are some objects that serve secular needs as well as figure in extraordinary or sacred situations, though sometimes they are in altered forms to distinguish them from the mundane mode. In North American society, for instance, the cup, plate, and cruets used in a Catholic mass are easily distinguished from those used in an ordinary meal.

In Native American cultures, on the other hand, the sacred was usually finely intertwined with the secular. Although some vessels had a purely sacred function, most everyday pottery had some sacred or extraordinary purpose.

There were some principally secular uses for pottery. It was traded with other groups, recycled by being crushed into temper for making other pots, and used as dishes and containers for storage and transportation. The Mississippi Valley cultures developed clay evaporators for boiling salt water to obtain salt, and a similar vessel was also used for boiling water off maple syrup, a process the Indians taught the French.

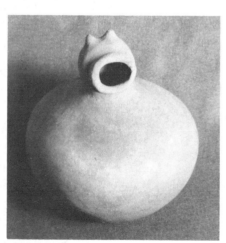
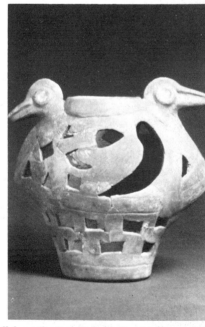

Animal effigy vessel (top), Sandy Woods, Missouri, mound culture, c. 500-1650 A.D. Not known whether this had secular and/or sacred use. Double-headed effigy openwork vessel (right), Weeden Island, Florida, 900 A.D. Possibly had sacred function as an incense burner.

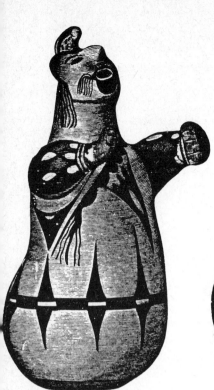

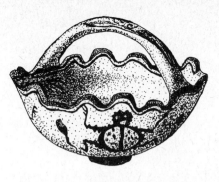

Zuni prayer-meal bowl, early 20th century.
Illustration by Sharon Wirt.

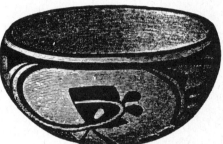

Cochiti water vessel, New Mexico.

Laguna eating bowl, New Mexico.

Bureau of Ethnology, 20th
Annual Report (1898-99),
Washington, D.C.: Government
Printing Office.

Salt pan as discovered, Missouri.
Photo courtesy of the National Anthropological Archive, Smithsonian
Institution.

11

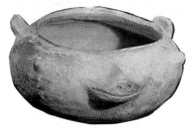
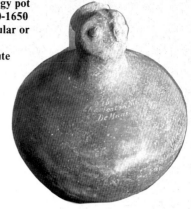

Of the pottery used for sacred purposes, pots in burials are one of the best examples. Although some pots in burials were reproductions of everyday ware, others had unusual, impractical shapes. In the southeastern and mound cultures, they held bones or ashes, and some were buried with individuals. In the Southwest, pottery buried with the deceased was ritually "killed" by breaking a hole through the center, either to release a spirit to accompany the deceased into the afterlife, or simply to discourage its secular use, it is conjectured.

Other sacred pieces include openwork ceremonial vessels, which were probably used as incense burners in the southeast; drums, which were used in ceremonies in the southwest, southeast, and New York State; and offering receptacles, which were found with mound culture altars in the midwest and the east. Prayer bowls from the southwest held sacred corn meal, and exhibit distinct motifs and shapes, but were not as well made as secular vessels.

In some Native American cultures, a sense of the sacred or the supernatural was also a part of the manufacturing process itself. It was considered good luck to behave in a certain way during the making and firing of a pot. The Navajo believed, for example, that the potter who worked unseen would be more successful. If there was a visitor present, clay was put on his or her body to prevent the pot from cracking, and both visitor and pot were given pollen for good luck. Visitors who had received the Wind or Shooting Chant as patients were not allowed to make pots or to observe them being made; it was considered bad luck to do so. A comparison might be drawn with the feeling of some North American writers and artists that it is bad luck to discuss a work in progress.

Adaptation

Native American peoples had the ingenuity to make the imaginative and intellectual leaps necessary to develop complex inventions when they first came to North America from Asia. But why did they not invent or adopt ceramic containers until about 2300 B.C. in the southeastern U.S., about 1000 B.C. in the Northeast, and about 600 B.C. in the Southwest? There are two archaeological approaches to answering this difficult question.

Some archaeologists believe that pottery was not necessary or advantageous to the survival of Native Americans until they began raising crops and living in larger, more stationary settlements. Before that, stone or wood containers and baskets were more suited to their nomadic lifestyle. Except for some of the stone vessels, most of these containers were lighter and more portable than pottery. They were also more readily made from accessible materials and therefore more easily left behind to lighten a traveling load. Pottery was too fragile to be practical, for it could easily be broken or damaged during a move to a new home.

Other archaeologists believe that inventions like pottery came about either through accidental discovery or through intentional experimentation by observant individuals. Some inventions were adopted because of their utility or other attractive features; others fell by the wayside, perhaps to be reinvented or rediscovered

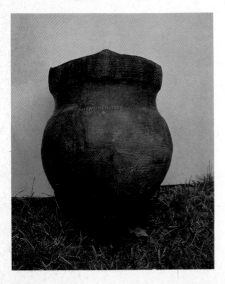

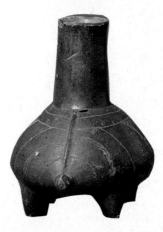

Four-legged vessel, Arkansas.
American Indian
Archaeological Institute
collection.

Mohegan vessel with castellated rim, Connecticut, c. 1500-1650 A.D.
Photo courtesy of the American Indian Archaeological Institute.

later—as with Leonardo da Vinci's design for the airplane. These archaeologists use examples such as the Northwest Coast peoples, whose villages were sizeable and relatively permanent, but who did not have pottery, to argue their case.

Perhaps the reasons for the invention of pottery lie somewhere between these two archaeological hypotheses.

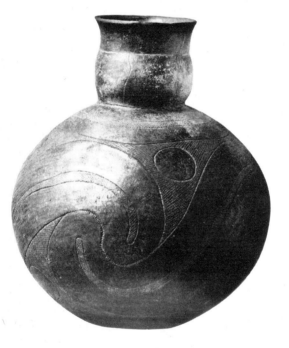

Incised vessel, Battle Place, Arkansas,
post 500 A.D. (top), and three-headed
effigy bottle, Georgia (right).
Photos courtesy of the National Anthropo-
logical Archive, Smithsonian Institution.

Pottery: A Technological Process

Through a long history of discovery, experimentation, and passing down pottery-making skills to the next generation, Native American peoples learned the properties and the promise of clay. The process of mixing clay, temper, and water and altering its form by using fire, sounds like a simple one-two-three procedure, but actually involves a specialist's knowledge and awareness. Learning the effects of temperature and humidity, and of particular fuels on certain types of clay, took years of experimentation.

The whole process began with clay—minute, decomposed rock (alumina and silica compounds, and frequently iron, alkalies, and alkaline earths) usually found along streams, rivers, lakes, in eroded seams or soil layers, and in dry, solid deposits in arid areas. The basic preparation of clay was similar all over Native America, though some variations existed in materials and methods. Regional and group differences were more prominent in the shaping and surface treatment steps of pottery making.

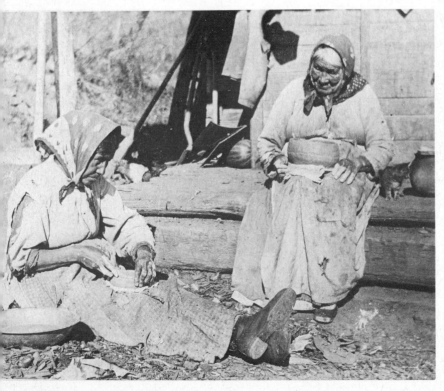

rokee potters, Qualla Reservation, North Carolina.
to by James Mooney, 1888 or 1900.
to courtesy of the National Anthropological Archive, Smithsonian Institution.

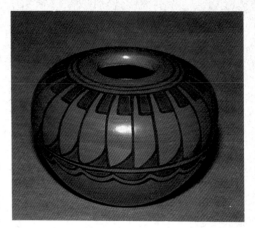

Pot by Minnie Vigil, Santa Clara Pueblo, New Mexico, late 20th century.
Photo courtesy of the American Indian Archaeological Institute.

BASIC STEPS:

1. *Clay is gathered* according to its quality and the type of vessel to be made.
2. *Clay is cleaned.* If dry, it is pulverized—pounded with, for example, mortar and pestle—and sifted or winnowed to remove any unwanted materials; if damp, it can be dried or impurities removed by hand.
3. *Water is added* for plasticity so that clay can be worked and molded.
4. *Temper is worked in,* consisting of crushed quartzite, shell, old potsherds, sandstone, sand, vegetal matter, or volcanic ash, depending on the group of people and the clay. Temper increases plasticity, reduces shrinkage and cracking while clay dries, and increases porosity and the clay's ability to withstand thermal (heat) shock. The potter had to know just how much to add to achieve all this.

Working temper (crushed sandstone) into clay.
Woodland Indian pottery techniques workshop.
American Indian Archaeological Institute, Washington, CT.

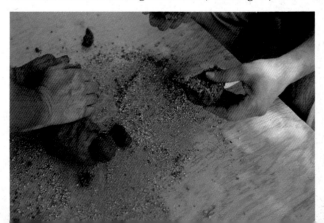

5. *Clay, temper, and water are mixed or kneaded together,* with no set formula other than the "feel" of the clay and sensitivity to climatic conditions. Consistency has to be just right or the pot will not hold up in the firing process.

6. *Clay is shaped.* The earliest pots were probably formed by pinching a ball of clay from the center outward. It is difficult to create large vessels using this technique. Coiling is more satisfactory and was the most widespread method used.

(a) Coils (rolled, sausage shapes) added one on top of another. In some settlements, base of vessel was molded onto gourd, basket, or broken pot, or in bark-lined hole in ground.

(b) Coils flattened to meld them together, then smoothed.

Coiling technique using molded base. Illustration by Sharon Wirt.

Tewa potters at work, New Mexico, c. 1890. Photo courtesy of the National Anthropological Archive, Smithsonian Institution.

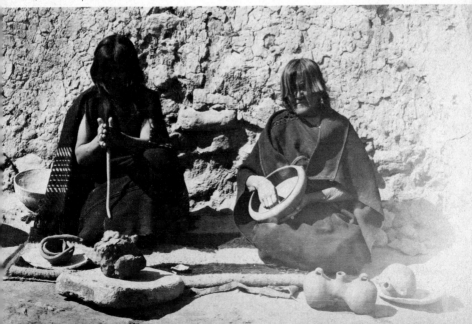

Paddle-and-anvil technique.
Illustration by Sharon Wirt.

 (c) Paddle (wooden paddle, pottery trowel, stone, etc.)-and-anvil (stone, potter's hand, etc.) method used in some settlements to strengthen vessel's walls by compacting clay particles and squeezing out air; to thin walls by evenly stretching clay; in some instances to apply surface decoration; or used as manufacturing process instead of coiling in some groups.

 (d) Bases of pots usually made spherical or conoidal because these shapes distributed heat more evenly (as in the *wok*, a Chinese cooking vessel).

 (e) Larger shapes attained by letting clay partially dry (to stiffen for support), then adding coils.

 7. *Surface is treated.* Method varied between as well as within settlements. Most surface finishing was done before the clay was completely dry. In the Eastern Woodlands and Midwest, decoration was sculptural and textural. In the Southwest and Mesoamerica, slipping, polishing, and modeling were the decorative methods.

Primitive Technologist Jeff Kalin twisting natural fibers into cordage to be bound around a stick, then used to apply decoration (cord roughening) to a vessel before firing. Woodland Indian pottery techniques workshop, American Indian Archaeological Institute. Photo courtesy of the Institute.

Replicated cord-wrapped stick.
Photo courtesy of the American Indian Archaeological Institute.

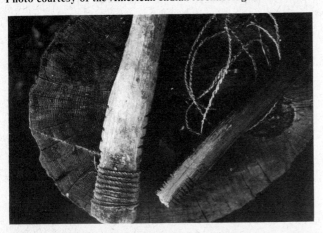

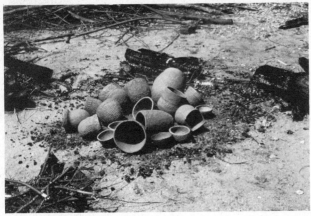

Pots ready for firing, being warmed by the sun. Firing area on top of ground is dried by low fire and hot ashes.
Photo courtesy of the American Indian Archaeological Institute.

8. *Pottery is dried,* ideally out of wind, in shade, slowly and evenly. Pots can warp or crack if drying is too rapid or uneven.

9 *Pottery is fired.* Procedure similar all over Native America: calm, dry days/nights, ample fuel, know-how, and patience.

(a) Most firings were done on the ground—in some cases in a depression lined with rocks or potsherds. Size, shape, fuel, time, temperature, etc., of firing and placement of pots depended on type of ware (porosity, size, and number of pieces) and effects (color, for example) desired.

(b) Fuel gathering—wood, grass, brush, dried animal manure, or whatever was available.

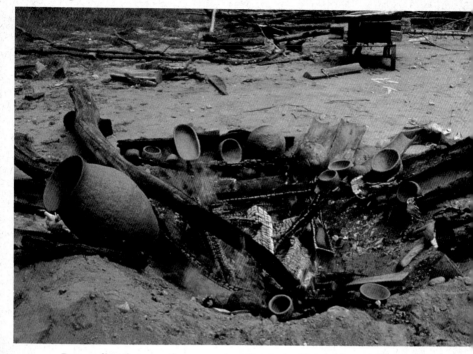

Pots acclimating near the preparatory fire. Later, firewood was laid over the pots tipi fashion and lit.
Woodland Indian pottery techniques workshop, American Indian Archaeological Institute.
Photo courtesy of the Institute.

(c) Pot heating—pots were first warmed in the sun, then slowly turned and gradually moved closer to the hot coals of the fire. Pots were then placed on top of the hot coals, and fuel was placed uniformly over and around the pieces. The fire was carefully tended to ensure even temperature rise and fall. It was best to allow the fire to cool and go out naturally.

In the Eastern Woodlands, *flashing*—dark, smoky areas—occasionally occurred on pots that had been touching one another and lacked oxygen during firing.

In the Southwest, a firing technique known as *reduction* was perfected. The fire was smothered with animal dung to cut off oxygen, and the result was blackware, such as that shown at the top of page 21. Some Eastern Woodlands vessels were purposely blackened (reduced) on the interior when vegetal material was tossed into them before firing. This apparently made the pottery watertight.

Example of reduction firing: polished blackware (center) by Maria, San
Ildefonso Pueblo, New Mexico, early 20th century. Two smaller pieces by
Haungooah, Santa Clara Pueblo, New Mexico, late 20th century.
American Indian Archaeological Institute collection.

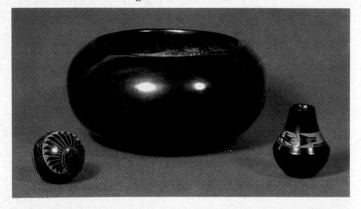

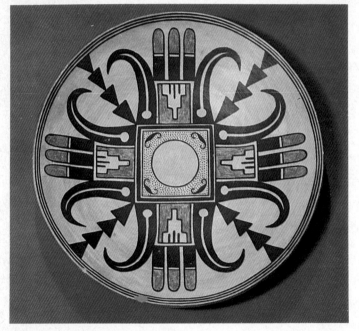

Polychrome plate by Maria and Julian Martinez, San Ildefonso Pueblo, New
Mexico, c. 1925.
Gunn Memorial Library and Historical Museum Inc. collection.

(d) Vessels were carefully removed from the fire and the ashes
 dusted off. Some potters greased pots to render them
 waterproof. Low-fire pottery was most desirable for cooking
 ware, as it was porous, heated up evenly, and withstood
 temperature changes well.

21

Potters—Artists and Craftspeople

The difference between art and craft is that a craft exhibits skill and aesthetic appeal but less originality than a work of art. Where does Native American pottery fit? A great many Native American pieces were variations on a theme, and it is impossible to know which pre-European contact vessels were originals. However, each piece can be considered on its own artistic merit. The anthropological work of Ruth Bunzel in 1924 and 1925 among Native American potters in New Mexico and Arizona showed that, while these women dipped into a common wellspring of designs and styles for their pottery, they spoke of being inspired by dreams, nature, and their own thoughts, some spending sleepless nights thinking of patterns.

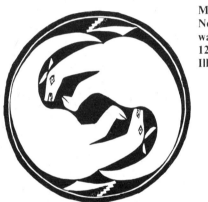

Mimbres vessel design, New Mexico. Note modern sophistication of design. It was created, however, in the 11th or 12th century A.D.
Illustration by Sharon Wirt.

Triple-ring jar, Caddoan, Arkansas, mound culture, c. 1300-1700 A.D.
Photo courtesy of the Museum of the American Indian, Heye Foundation, New York.
Photo by Carmelo Guadagno.

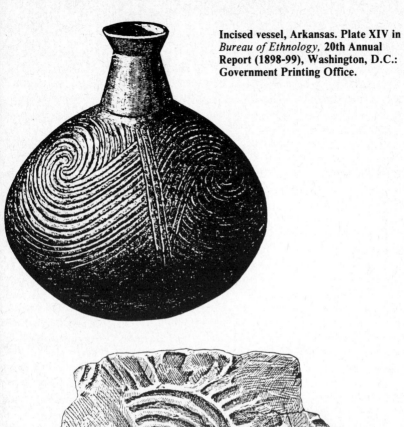

Incised vessel, Arkansas. Plate XIV in *Bureau of Ethnology,* 20th Annual Report (1898-99), Washington, D.C.: Government Printing Office.

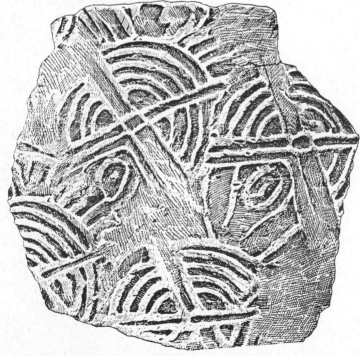

Potsherd with stamped decoration, Florida peninsula. Plate LXXXVIII in *Bureau of Ethnology*, 20th Annual Report (1898-99), Washington, D.C.: Government Printing Office.

Design appears to have been passed on from generation to generation within Native American settlements. Ceramic art changes just as language changes over time, by new needs, by borrowing from other cultures, and by playful or serious invention. Perhaps variations occurred from group to group because accidents developed into traditions within a group, and because each group perceived itself differently from the others. Note the changes in Northeastern pottery through time (below).

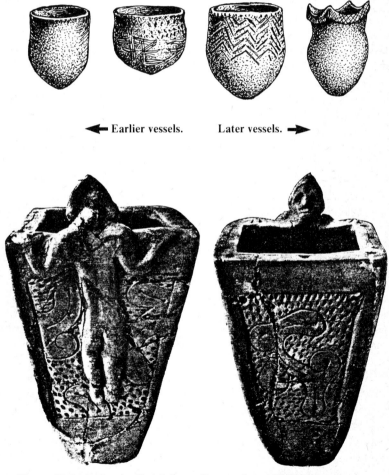

◄— Earlier vessels. Later vessels. —►

Vase with incised and relieved decoration, northwest Florida coast.
Bureau of Ethnology, 20th Annual Report (1898-99), Washington, D.C.: Government Printing Office.

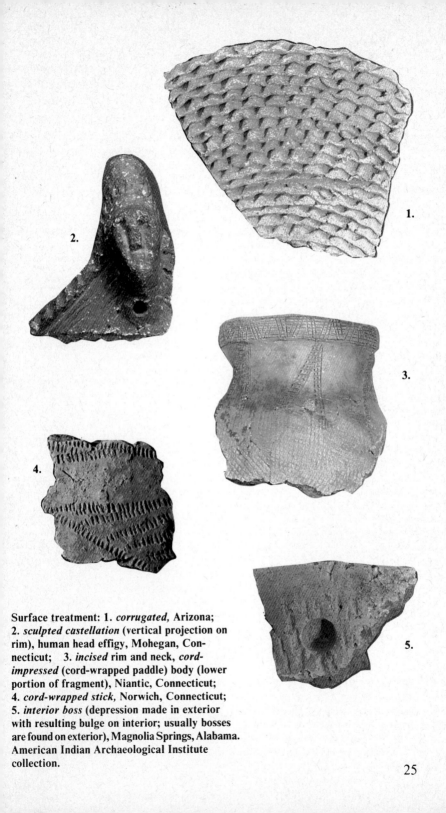

Surface treatment: 1. *corrugated,* Arizona;
2. *sculpted castellation* (vertical projection on
rim), human head effigy, Mohegan, Con-
necticut; 3. *incised* rim and neck, *cord-
impressed* (cord-wrapped paddle) body (lower
portion of fragment), Niantic, Connecticut;
4. *cord-wrapped stick,* Norwich, Connecticut;
5. *interior boss* (depression made in exterior
with resulting bulge on interior; usually bosses
are found on exterior), Magnolia Springs, Alabama.
American Indian Archaeological Institute
collection.

An example of change within a group is the appearance of polychrome pottery (pieces with three or more colors). Archaeologist Paul S. Martin is one who wonders if it was an accidental creation that became popular or a deliberate development by increasingly complex societies that needed more sophisticated symbols to denote status, prestige, and privilege. While a firm answer may never be possible, anthropologists continue to try to understand behavioral processes and the relationship of art to culture.

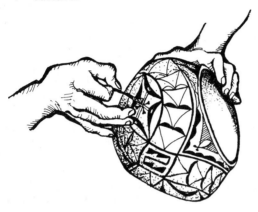

Painting a design on a pot with colored slip (a thin solution of fine clay and water) using a paintbrush of chewed yucca.
Illustration by Sharon Wirt.

Surface treatment: *fabric impressed,* Norwich, Connecticut.
American Indian Archaeological Institute collection.

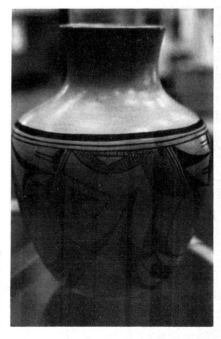

Surface treatment: *slipped, painted, and polished,* Hopi, Arizona. (Polishing is done by rubbing a smooth stone or rag over the surface of the vessel.)
Photo courtesy of the American Indian Archaeological Institute.

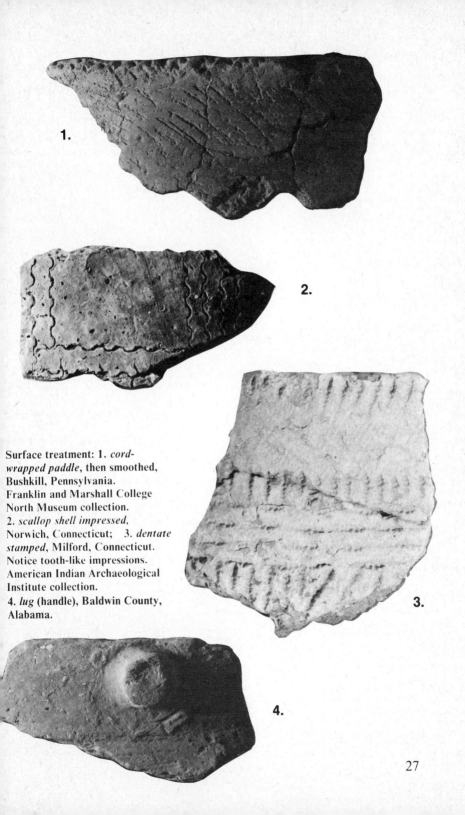

Surface treatment: 1. *cord-wrapped paddle*, then smoothed, Bushkill, Pennsylvania. Franklin and Marshall College North Museum collection.
2. *scallop shell impressed*, Norwich, Connecticut; 3. *dentate stamped*, Milford, Connecticut. Notice tooth-like impressions. American Indian Archaeological Institute collection.
4. *lug* (handle), Baldwin County, Alabama.

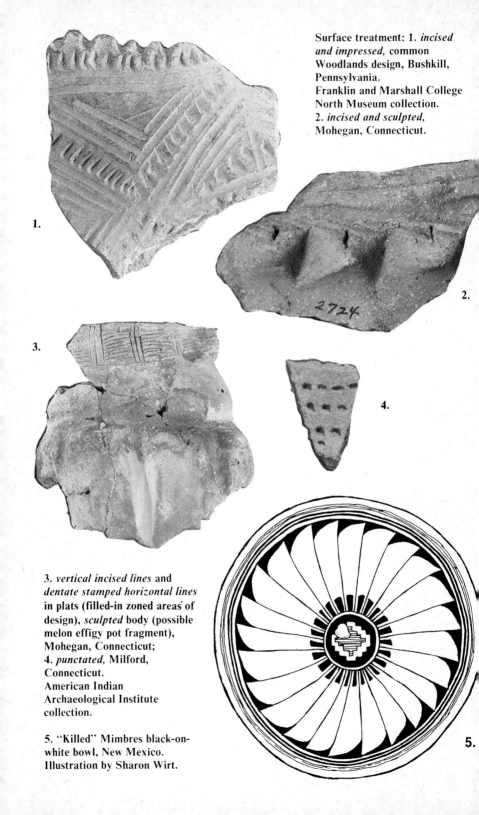

Surface treatment: 1. *incised and impressed,* common Woodlands design, Bushkill, Pennsylvania.
Franklin and Marshall College North Museum collection.
2. *incised and sculpted,* Mohegan, Connecticut.

1.

2.

3.

4.

3. *vertical incised lines* and *dentate stamped horizontal lines* in plats (filled-in zoned areas of design), *sculpted* body (possible melon effigy pot fragment), Mohegan, Connecticut;
4. *punctated,* Milford, Connecticut.
American Indian Archaeological Institute collection.

5. "Killed" Mimbres black-on-white bowl, New Mexico.
Illustration by Sharon Wirt.

5.

"Killed" Mimbres pot, New Mexico. Photo by Hillel Burger.
Photo courtesy of the Peabody Museum. Harvard University.

However homogeneous (socially uniform) and traditional Native American groups were, there evidently was room for creative individual potters. Sometimes differences were subtle. Anthropologist Ruth Bunzel could not identify individual creators of ceramic works when she first began studying pueblo potters in Arizona and New Mexico. Members of these pueblos could do so by examining paint thickness, line quality, and the character of patterns. Some ceramic art exhibited sharp stylistic differences within the group — for example, that of the Mimbres people, thought by some archaeologists to be the ancestors of the Zuni of New Mexico. The two distinct styles of Mimbres pottery appear to have been created by two different groups, yet they exist side by side. (See illustration 5, p. 28.) Certain researchers believe the individualistic, lively style (illustration at top of page) was the work of one or of a few Mimbres artists. This adds credence to the idea that artists were sensitive to and reflected their group's beliefs, lifestyle, and aesthetic vocabulary, but could also introduce entirely new modes of expression. Ceramic creativity, like creativity in the other arts, was both bound and unbound by culture.

29

Conclusion

A contemporary southwestern pueblo potter once told anthropologist Ruth Bunzel, "We paint our thoughts." An exquisite, succinct description! Today, all over the country, Native American potters continue to mold earth and water according to their thoughts. And, as in all cultures, thinking changes to greet new challenges and as a result of experimentation. Some potters continue age-old traditions of form and pattern; others blend old and new in stunning ways; still others create novel, provocative departures from the traditional—expressing individualistic thoughts and visions.

The imagery of Indian pottery grew gradually out of the profound experiences of tribal histories. It is an iconography which has such a spontaneous and holistic relationship to a people's grasp of reality that it speaks to them silently, almost automatically, like the images of their dreams.

Jamake Highwater
From the Foreword
Master Pueblo Potters, ACA Galleries
New York, NY, 1980

 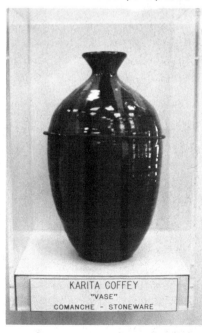

Pot by Lucy Lewis, Acoma, New Mexico, 20th century (left). Stoneware vase by Karita Coffey, Commanche, 20th century (right).
Photos courtesy of the American Indian Archaeological Institute.

Selected Sources

Bunzel, Ruth L. 1972. *The Pueblo: A Study of Creative Imagination in Primitive Art.* New York: Dover Publications, Inc.

Emerson, J. Norman. 1968. Understanding Iroquois Pottery in Ontario: A Re-Thinking. *The Ontario Archaeological Society.* Special Publication (March).

Frank, Larry and Francis H. Harlow. 1974. *Historic Pottery of the Pueblo Indians, 1600-1880.* Boston: New York Graphic Society.

Hill, W. W. 1937. Navajo Pottery Manufacture. *The University of New Mexico Bulletin.* Anthropoligcal series, Vol. 2, No. 3.

Holmes, W. H. 1903. Aboriginal Pottery of the Eastern United States. *Annual Report of the Bureau of American Ethnology.* Washington, D.C.: Government Printing Office. 20th Annual Report (1898-1899).

Howes, William J. Various articles on New England Indian pottery in: *Bulletin of the Massachusetts Archaeological Society* 5(1):1, 15(2):23, 15(4):81, 16(1):9, 17(2):30, 17(3):52, 21(3-4):54.

Kimball, Katherine. 1979. The Potter: Pre-Columbian Cultures of the Southeastern United States. In *The Ancestors: Native Artisans of the Americas.* Published by the Museum of the American Indian. New York: Heye Foundation. Pp. 160-177.

Kinsey, W. Fred III. 1972. *Archaeology in the Upper Delaware Valley.* Harrisburg: The Pennsylvania Historical and Museum Commission.

Longacre, William A. 1970. *Archaeology as Anthropology: A Case Study.* Tucson: University of Arizona Press.

Martin, Paul S. and Fred Plog. 1973. *The Archaeology of Arizona: A Study of the Southwest Region.* Garden City, NY: Doubleday Natural History Press.

Matson, Frederick. 1965. *Ceramics and Man.* Chicago: Aldine Publishing Co.

McNeish, Richard S. 1952. Iroquois Pottery Types: A Technique for the Study of Iroquoian Prehistory. *National Museum of Canada Bulletin.* No. 124.

Museum of the American Indian. 1972. *Naked Clay: 3000 Years of Unadorned Pottery of the American Indian.* New York: Heye Foundation.

Niethammer, Carolyn. 1977. *Daughters of the Earth.* New York: Collier Books.

Powell, J. W., Director. 1883. Illustrated Catalogue of the Collections Obtained from the Indians of New Mexico and Arizona in 1879, by James Stevenson. In *Annual Report of the Bureau of Ethnology.* Washington, D.C.: Government Printing Office. 2nd Annual Report (1880-1881). Pp. 322-365.

Rouse, Irving. 1947. Ceramic Traditions and Sequences in Connecticut. *Bulletin of Archaeological Society of Connecticut.* No. 21.

Shepard, Anna O. 1976. *Ceramics for the Archaeologist.* Washington, D.C.: Carnegie Institution of Washington. Publication 609.

Spivey, Richard L. 1948. *Maria, Potter of San Ildefonso.* Norman: University of Oklahoma Press.

Willey, Gordon R. 1966. *An Introduction to American Archaeology.* Englewood Cliffs, NJ: Prentice-Hall, Inc., Vol. 1.

Index